SHIT LONDON 2

EVEN MORE SNAPSHOTS OF A CITY ON THE EDGE

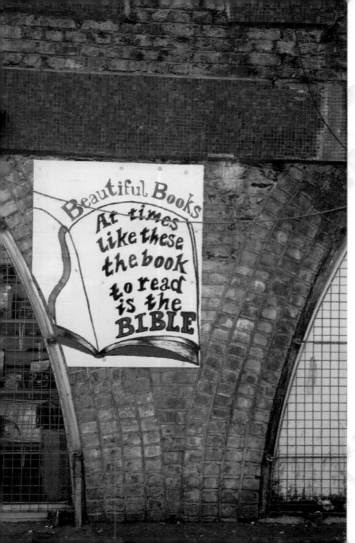

First published in the United Kingdom in 2012 by
Portico Books
10 Southcombe Street
London
W14 0RA

An imprint of Anova Books Company Ltd

ISBN 9781907554735

A CIP catalogue record for this book is available from the
British Library.

10 9 8 7 6 5 4 3 2 1

Printed and bound by Everbest Printing, China

This book can be ordered direct from the publisher at
www.anovabooks.com

For more *Shit London* stuff why not head over to
www.shitlondon.co.uk, or be part of the group on Facebook.

SHIT LONDON 2

EVEN MORE SNAPSHOTS OF A CITY ON THE EDGE

PATRICK DALTON

PORTICO

Nobody is healthy in London. Nobody can be.
Jane Austen

WELCOME TO SHIT LONDON ... AGAIN.

In the year and a bit since the last volume of *Shit London* was compiled our capital city has seen a Hell of a lot of action. The great pre-Olympic clean-up rolled on and intensified just as millions of visitors flocked to witness the Royal Wedding. A few months after that half the city went batshit-crazy and indiscriminately burnt down or looted almost every precious branch of Carphone Warehouse and Foot Locker we posess. Those were dark days and many wondered if we could claw our way back from the brink of complete anarchy. Luckily it began to rain, the looters stayed in, people took the boards down from their windows, realised that the damned Victoria Line was closed again and got on with the daily business of being Londoners.

Londoners are a special breed, you see. Yes, we might look grim-faced during the morning commute but if you scratch just beneath the surface you'll find that we're more than that ... we're totally and utterly miserable. The thing is though, we wouldn't have it any other way. Misery and dissatisfaction are our default settings. The average Londoner wouldn't have anything to discuss if they didn't have something to moan about. Be it the weather, tube fares, cyclists or charity muggers with their relentless faux cheer, these topics grease the cogs of our big society and automatically create common ground between us all to bitch and moan about.

Like swapping stickers in the playground, hundreds of other Londoners have sent me their photos for inclusion in this new volume of shitness. Of course, over the years, it has become inevitable that I've started to receive the same bit of graffiti, or vandalised landmark, but it seems that London is a particularly rich seam of unique 'shit' too, as I'm constantly

surprised by the amount of new photos that get sent to me at the *Shit London* website. With that in mind, it's perhaps unsurprising that the *Shit London* blog has become a flag under which to gather for Londoners to point out, discuss and even celebrate the crumminess, mediocrity and weirdness that exists in their city. The amount of it out there is quite staggering, after all. For your viewing pleasure, I've continued my adventures across the city prospecting for strangeness and publishing my discoveries online.

It's an odd existence, I'll admit. Take the 'Gentrify This' image opposite. I received a tip-off from a friend that he'd seen this great piece of 'knobism' (as I call it) that very morning in Hackney Wick and that it was definitely worth me getting a shot. An hour later I was there, standing in freezing drizzle on a roundabout, taking photos through the gaps in the perpetual convoy of cement lorries heading in and out of the Olympic site. In moments like that some doubt can creep into your mind. Is this really how I saw my life panning out? What would my childhood self think about all this? He wanted to be Han Solo or a pop star and this is where you've brought him, to a grim roundabout, taking photos of a giant cock rendered in spray paint on a demolition site's hoarding. Obviously, all these doubts disappeared when I heard that the next day someone had come along and painted over all trace of the graffiti. Many of the *Shit London* photos I see capture things that are impossibly transient, they pop in and out of existence, fragile, like particularly mundane butterflies. Someone has to be in the right place, at the right time to capture them. Otherwise they vanish forever.

Inside this book you'll find more odd detritus from London life, creakingly-bad pun names, highly offensive handwritten notices, questionable design choices, strange local newspaper headlines, shitty misspellings and much more. I urge you to look at each one and consider the story behind them. Ask yourself why someone named their shop that particular name? Why the fancy dress shop owner thought that would be a good costume choice for a child? And just why is 'Nanu' so angry with the world?

Patrick Dalton, June 2012

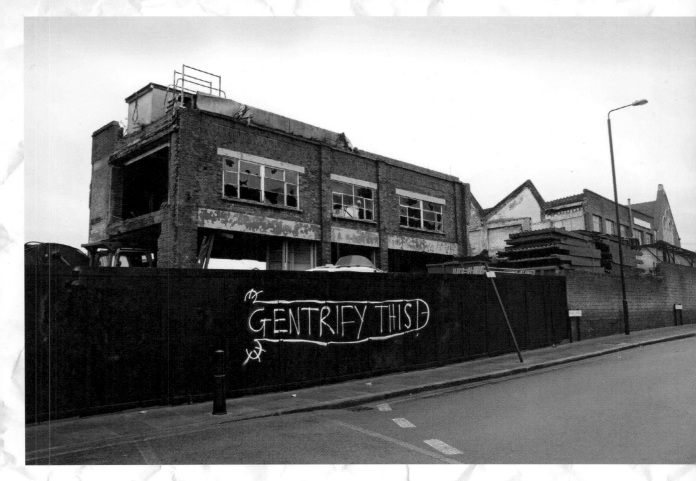

Gentrify that, Hackney Wick

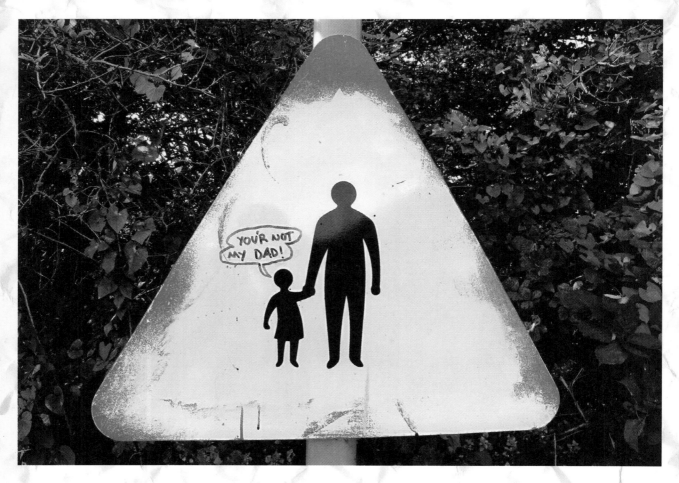

Stranger danger, Walthamstow Marshes

Security advice from Lambeth Council, Vauxhall

Hackney Gazette
www.LONDON24.com

Hackney Gazette
www.LONDON24.com

DRAG QUEEN'S FURY AT NOISE HELL

Hell hath no fury like
a drag queen, Hackney

You wouldn't hit a man with lots of glasses?, Earlsfield

You want flies with that?, East Ham

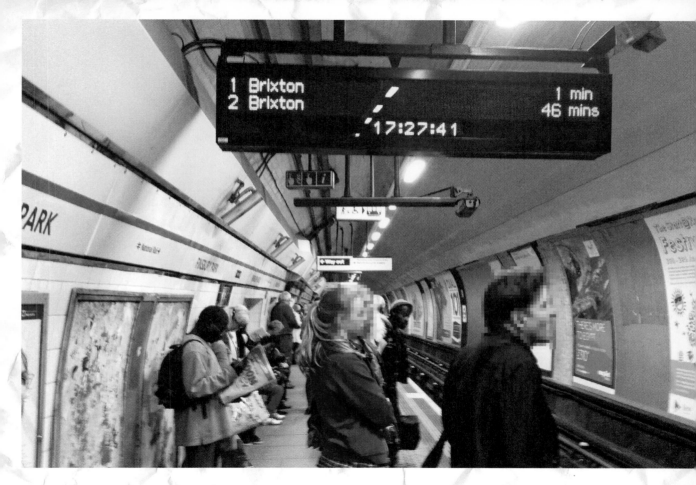

Might as well walk, Victoria Line

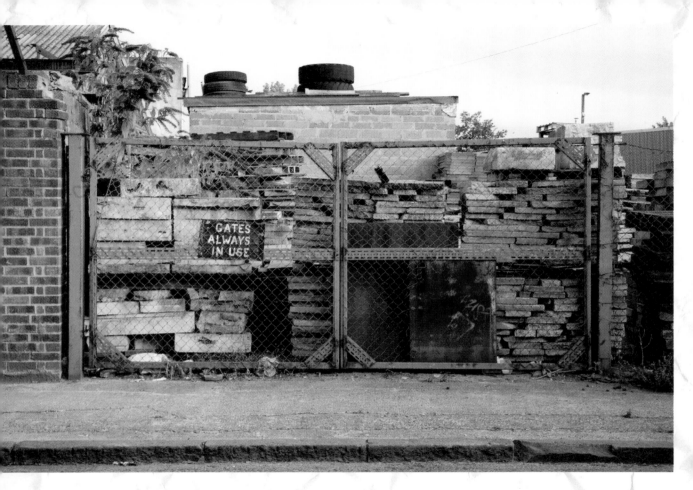

Dishonest gates, Hackney Wick

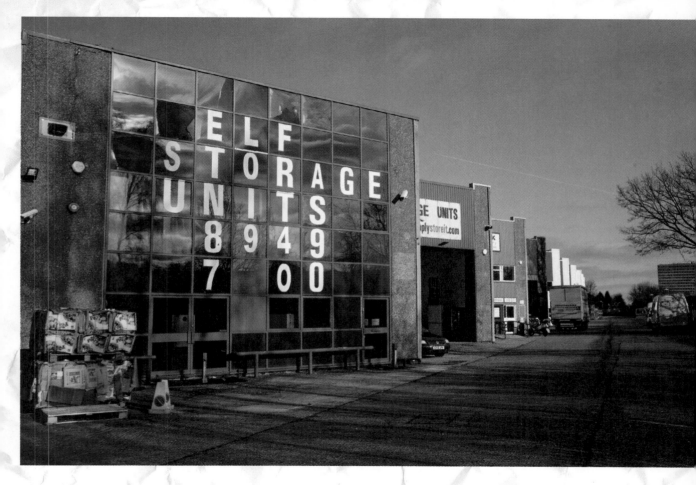

Fantasy creature storage, New Malden

75p

48.4p per 100g

and Clubcard points too

T 2

067289500-0006/5010176150558/04

GOBLIN
MEAT PUDDING
155G

Fantasy creature double entendre, Tesco, Lewisham

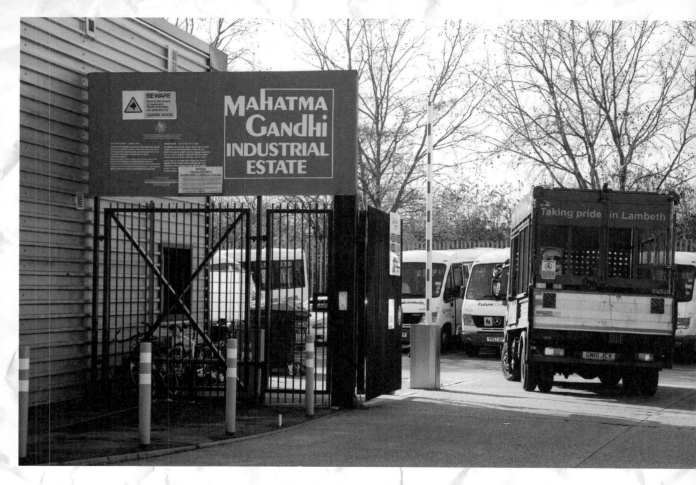

Gandhi – Father of a nation and a small industrial estate, Brixton

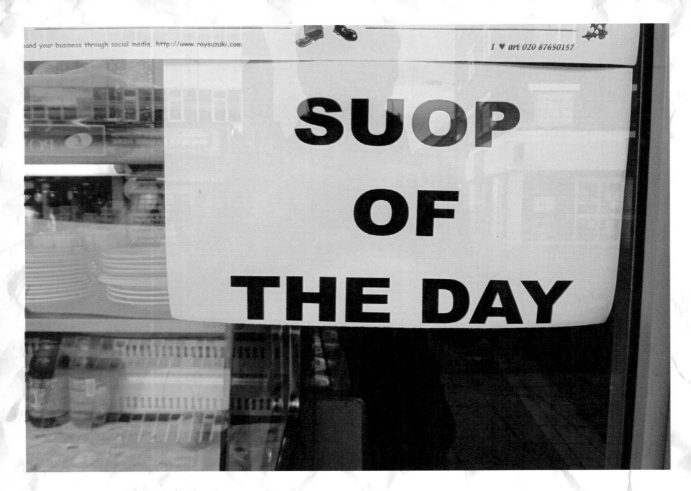

Misspelled soup, Walworth Road

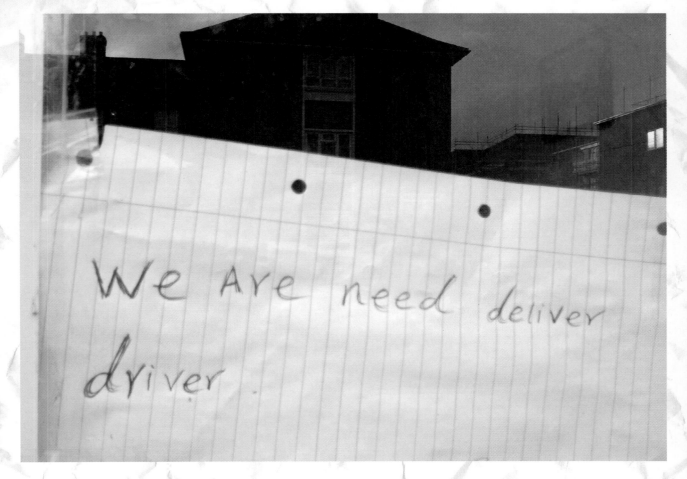

Shit recruitment notice, Clock House

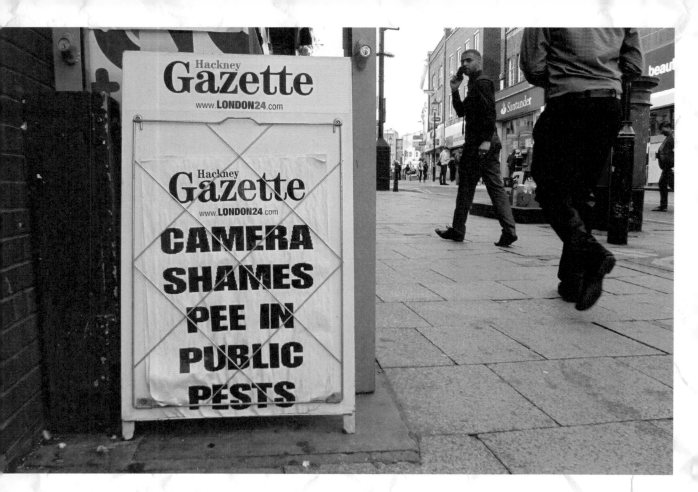

Urine trouble, Hackney Central

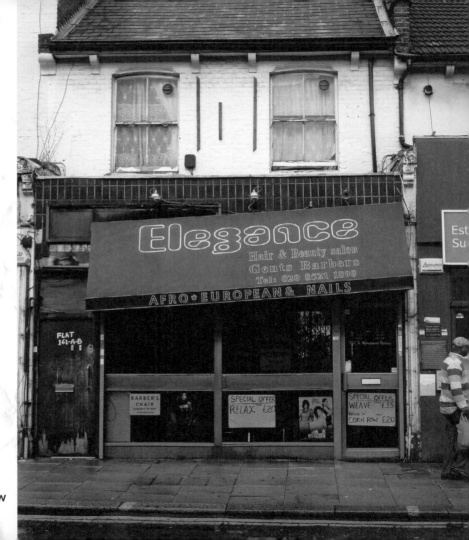

Irony, Walthamstow

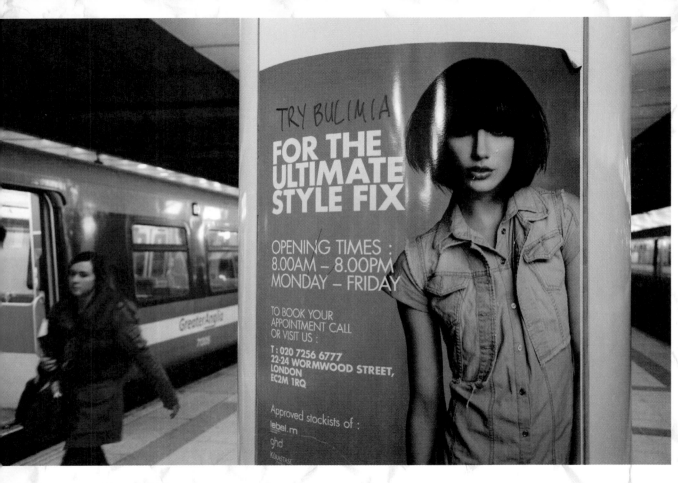

Style advice, Liverpool Street

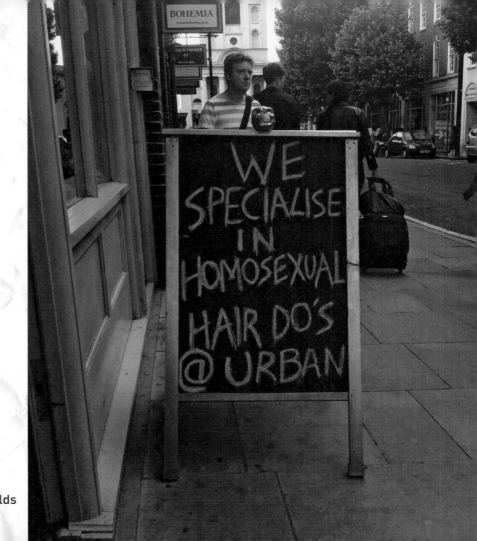

Hairdresser's sign, Spitalfields

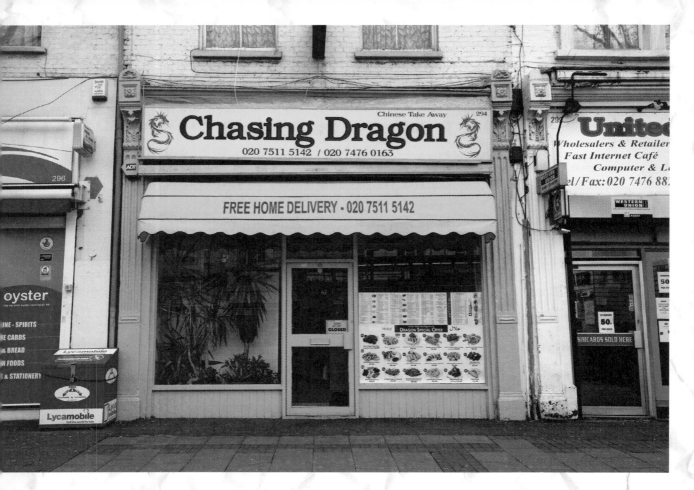

Dangerously moreish, Barking Road

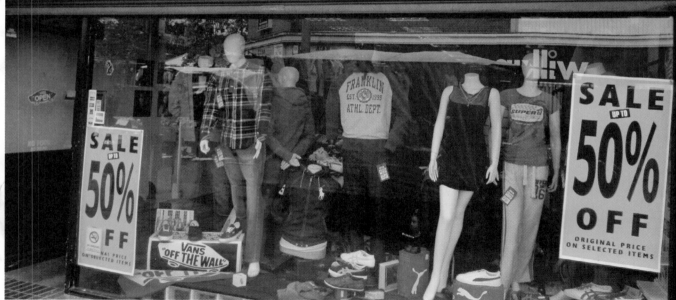

Fashion abuse, Walthamstow

Special services, Newington Causeway

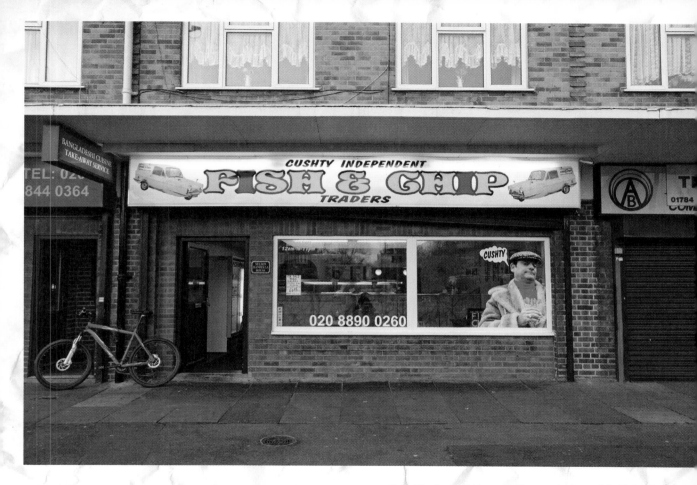

Only Fools and Horses themed shop #1, Feltham

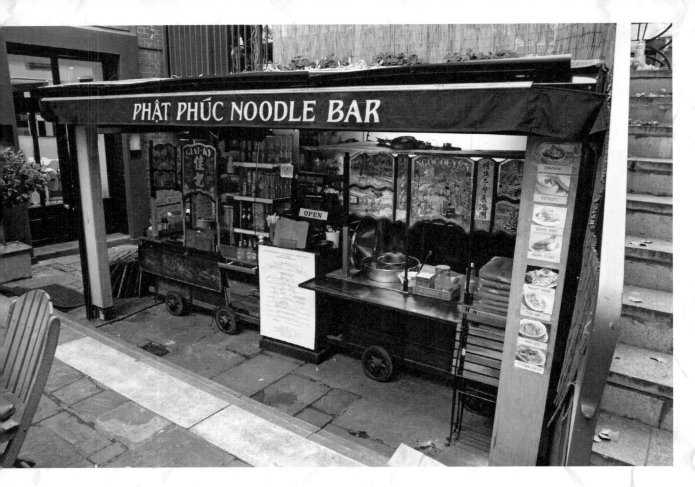

Noodle bar, Chelsea

Über kampf, Holloway Road Tube

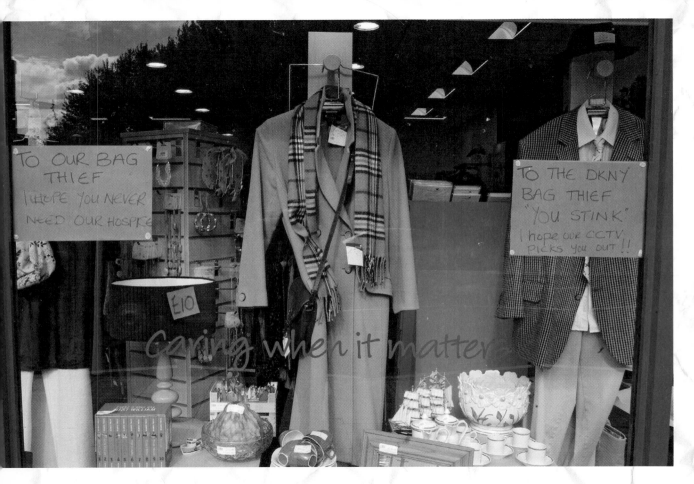

Caring when it matters, Wimbledon

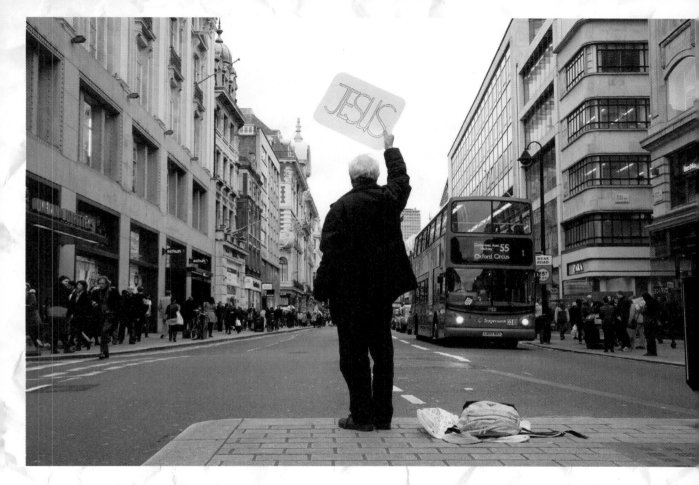

Messiah hailing, Oxford Street

Deeply cynical business name, Wembley

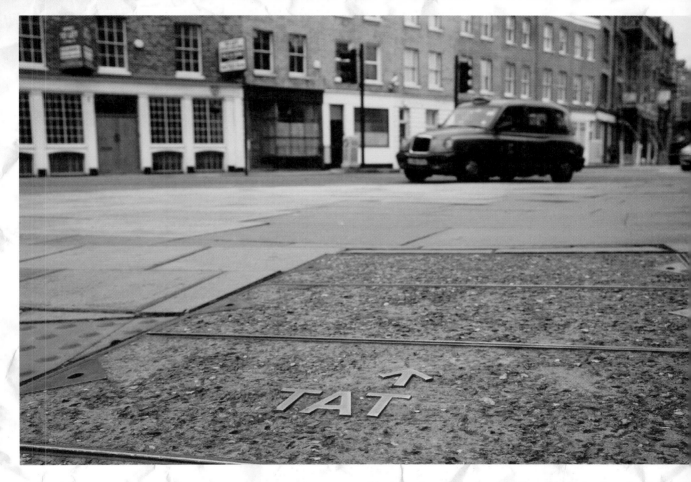

Disparaging directions to Tate Modern, Southwark

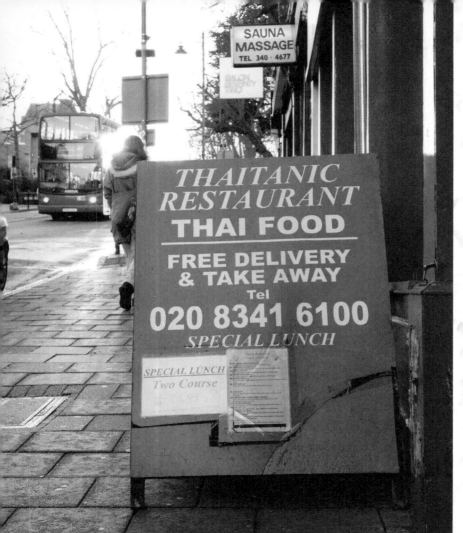

Tragic disaster pun, Crouch End

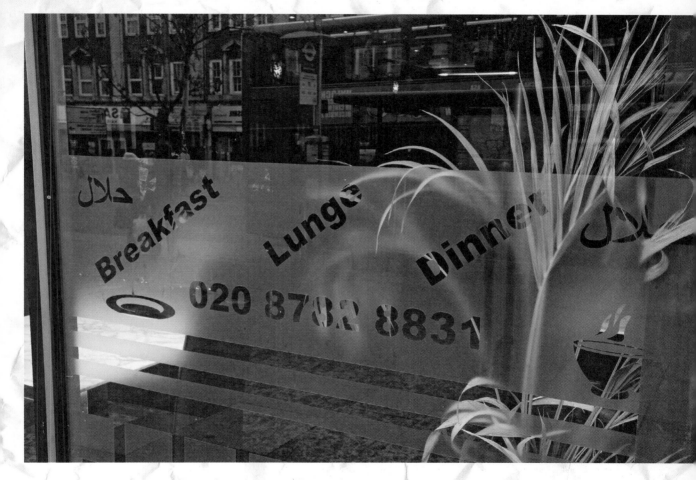

New health regime, Wembley

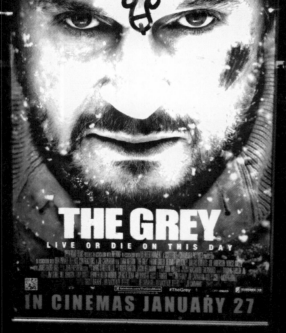

Liam Knobson,
Great Eastern Street

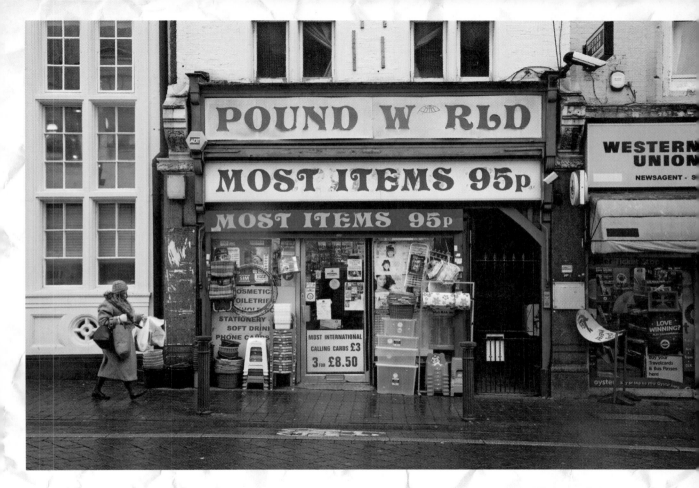

High road, Leytonstone

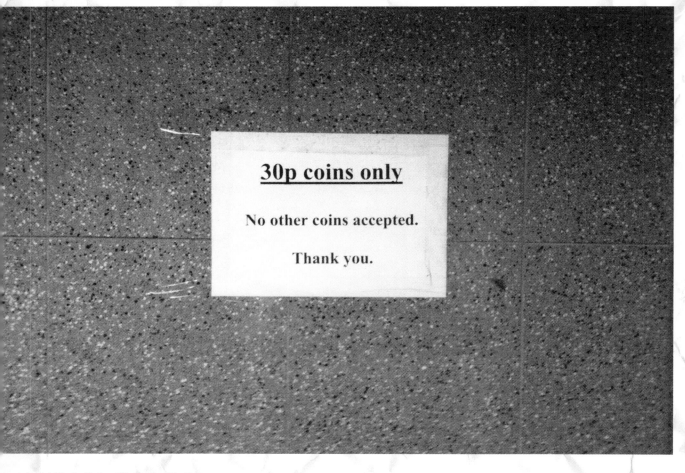

30p coins only

No other coins accepted.

Thank you.

Public toilets, Victoria Station

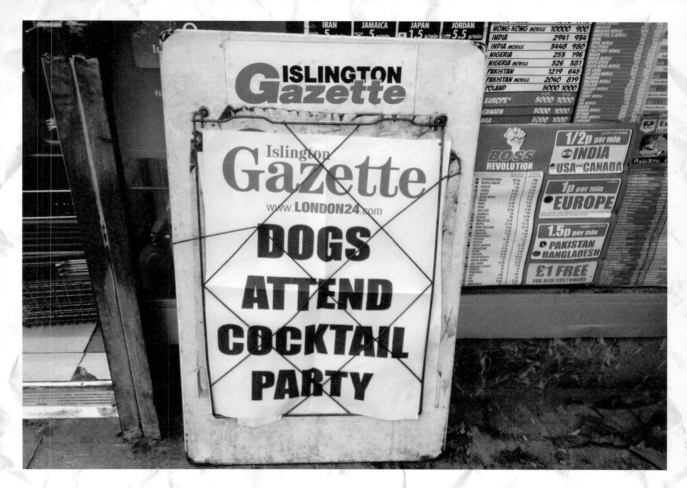

All the news that matters, Islington

Caribbean bream, White City

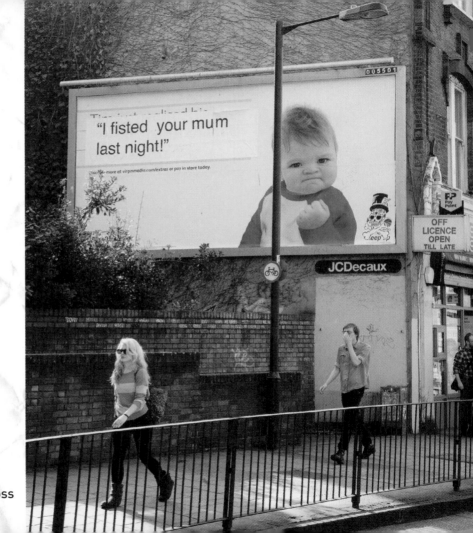

Student prank, New Cross

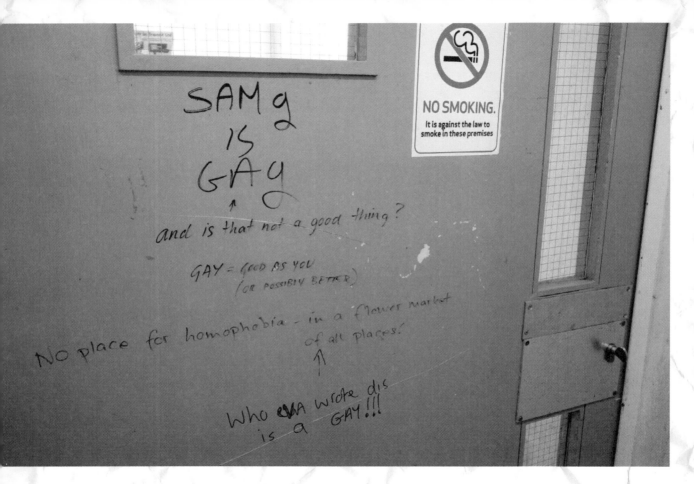

Door debate, New Covent Garden Flower Market

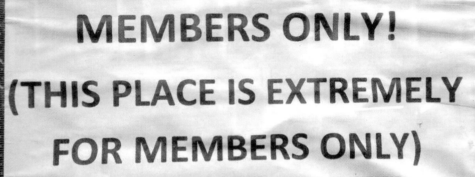

Don't mess, Stoke Newington

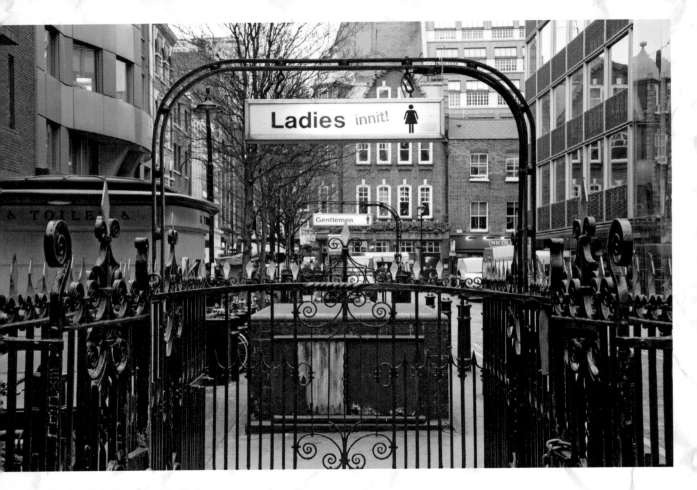

Ladies' toilet, Broadwick Street

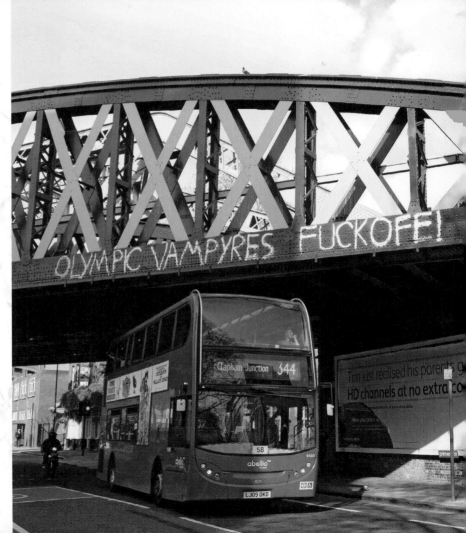

Anti-Olympic vampire graffiti,
Borough

stew with sage &
mustard dumplings 12.50

Hand rolled thin cunt
pizza 11.00

— goat cheese & spinach
— sausage & jalapeno pepper
— olive & anchovy
— four cheese

In no way does that spell 'crust', Shoreditch

In 1999 the rate of single-parent families among black families was 56 percent; among Hispanic families, 32 percent; and among white families, 20 percent. Higher rates of black single-parent families result from higher rates of out-of-marriage. The percentage of babies born outside marriage to British-born mothers rose from 38.7 per cent in 1996. (Heb 12: 1-10: Deuteronomy 23: 2).

Ladies now this day have lost value and respect of themselves only about .001% has availability while **God** has created them for something **wonderful** and called them to be a **helper to Man (Gen. 2: 21-24)** and **(Prov. 31: 10-11, 18, 22-26).** Another one is **tattoos, eyelashes and piecering**: it has been put in different ways and places in the bodies: Yes, it is yr body W**oe & Shameless** women and men. They prefer fake than the original from heaven, **God's made!** Mothers and fathers telling children to be carrying condoms—it isn't in God's word. **Shameless!**

Britain will soon experience bad things like **tsunami or trembling:** lots of lives will be lost, families' life, children will be motherless, fatherless and others will be childless. However, they is hope, because they are people who God has turn they lives around.

Dear Heavenly Father: I come to U, confessing that I have sinned against U. I am sorry for my sin and believe that Jesus Christ came to the earth to die for me to have eternal life. Lord helps me to be different from now on in your wonderful name Jesus Christ. Amen.

Insane notice, Peckham

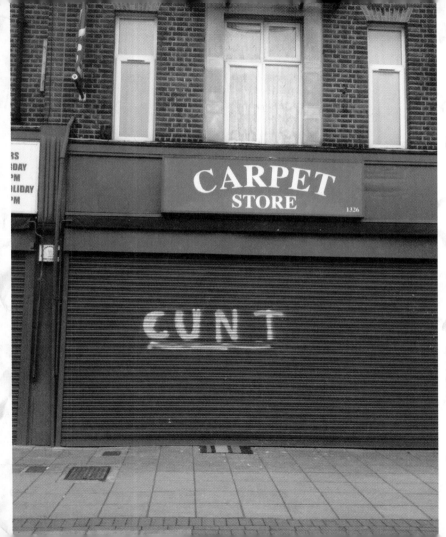

**Makes a difference from
'Sale Now On', Greenford**

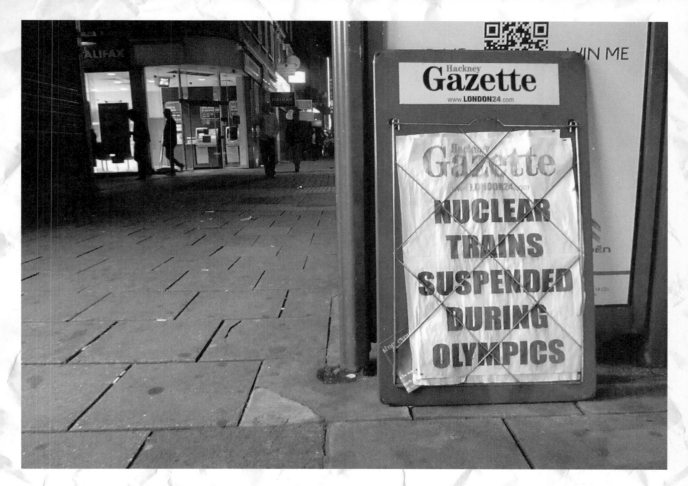

Kingsland High Road, Dalston

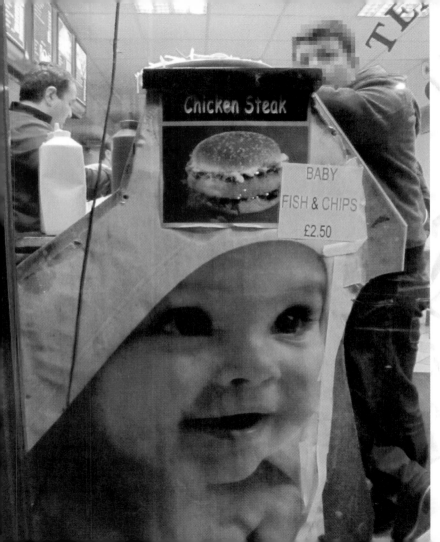

Giant chip shop baby,
Tooting Broadway

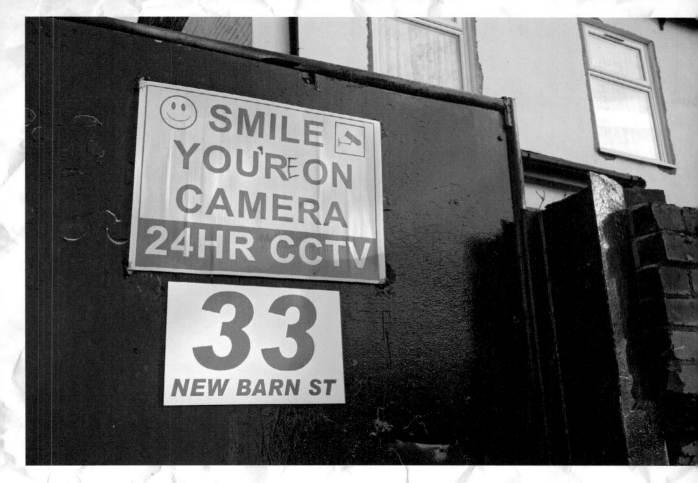

Corrected grammar, Plaistow

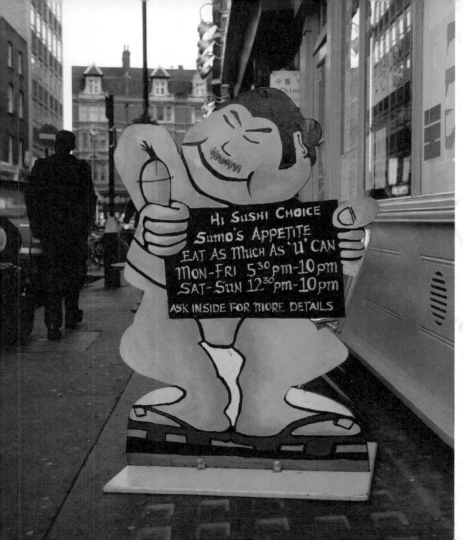

Sumo knob thumb, Frith Street

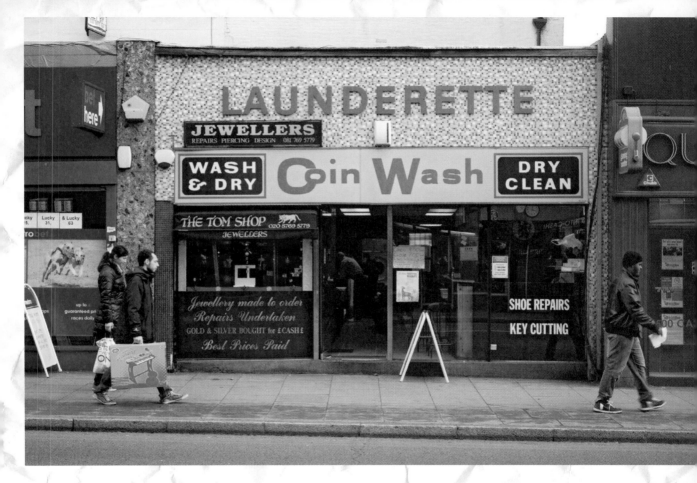

Money laundering, Streatham

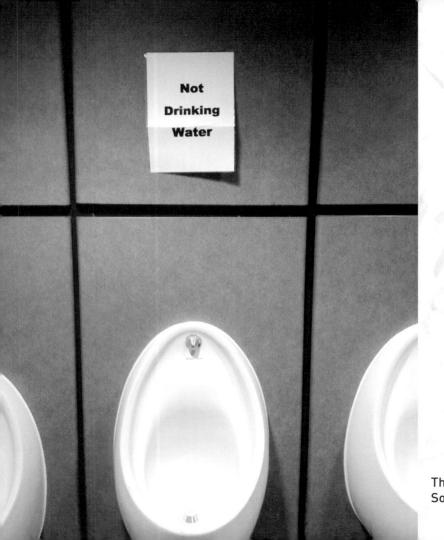

There's always one isn't there?,
Somerset House

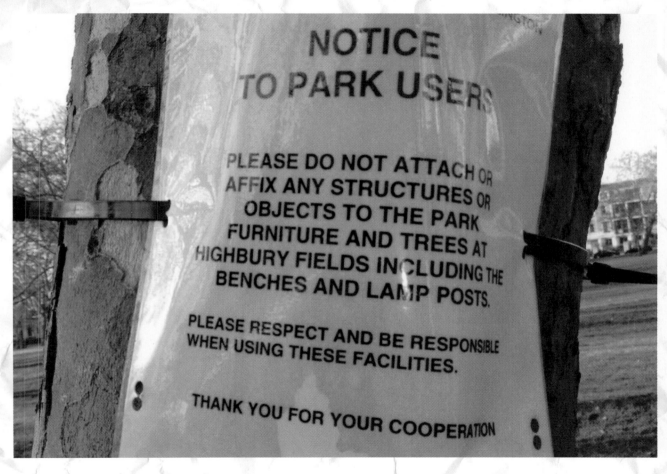

Smell the irony, Highbury Fields

Dirty protest, Queensway

DEAR COSTUMERS.
EVERY FRIDAY
FROM
1:30PM – 1:50PM
THE INTERNET
SIDE OF THE SHOP
WIIL BE CLOSED
THANKS.

Costumers beware, Hackney Central

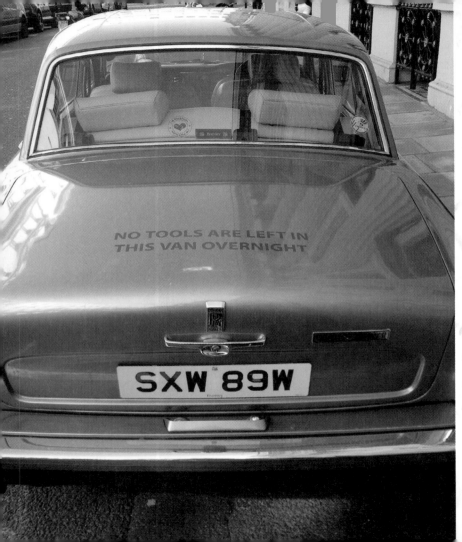

Nouveau riche, Bond Street

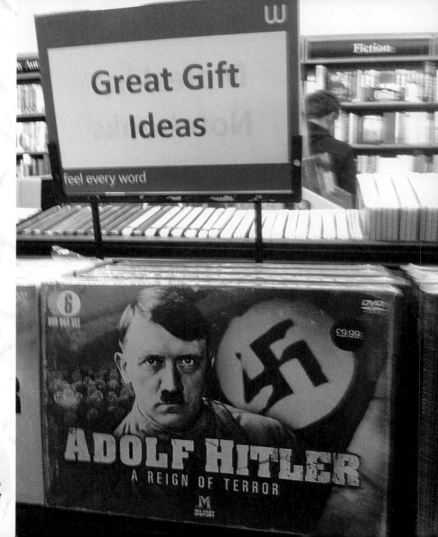

For that special Nazi in your life,
Piccadilly

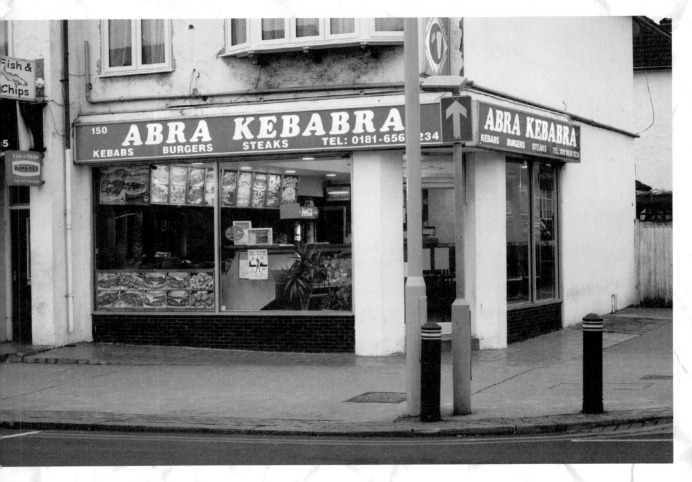

Magic kebab pun, New Addington

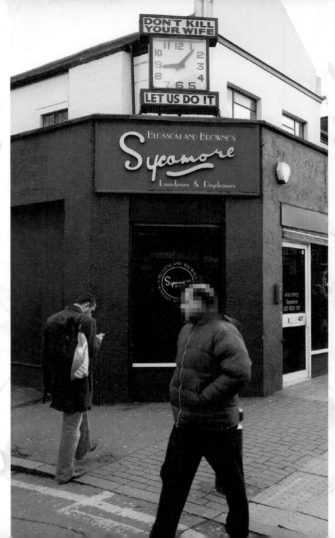

Murderous clock, Upton Park

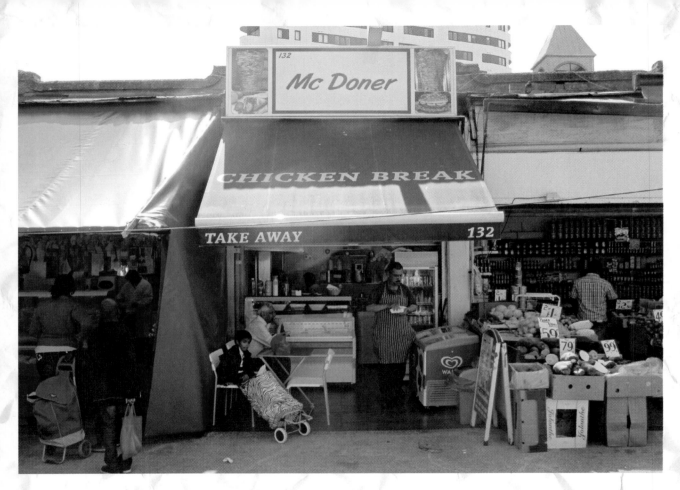

Café copies McDonald's, Ridley Road Market

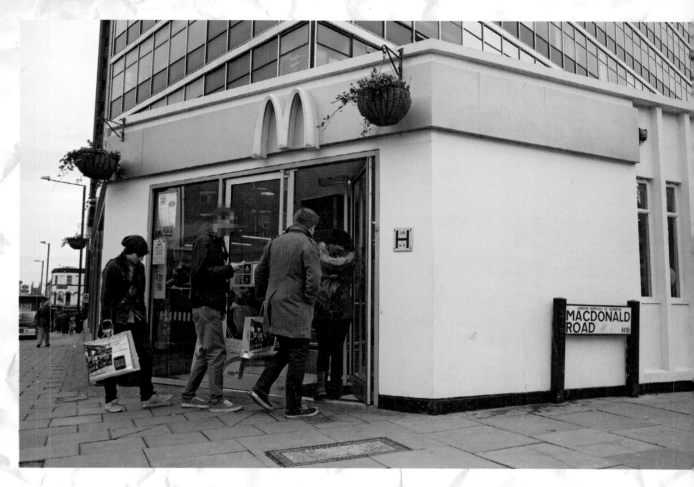

McDonald's copies road, Archway

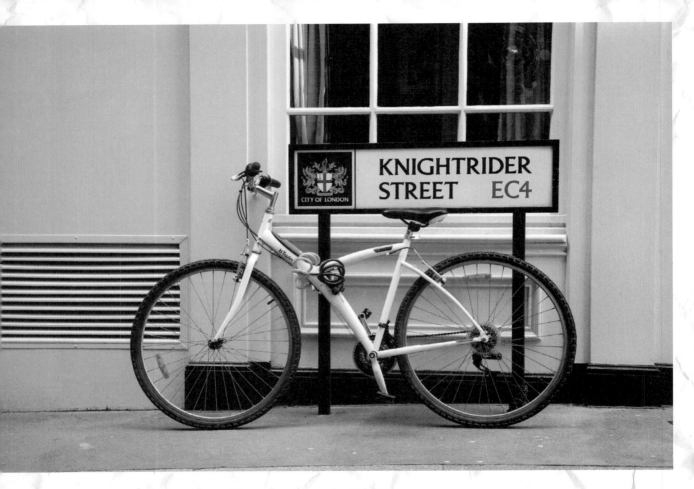

Michael Knight's cutting down on his carbon footprint, The City

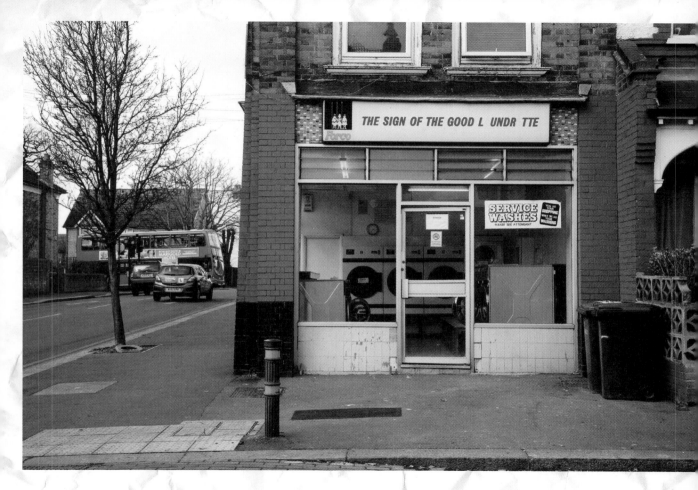

Ironic laundrette sign, Streatham

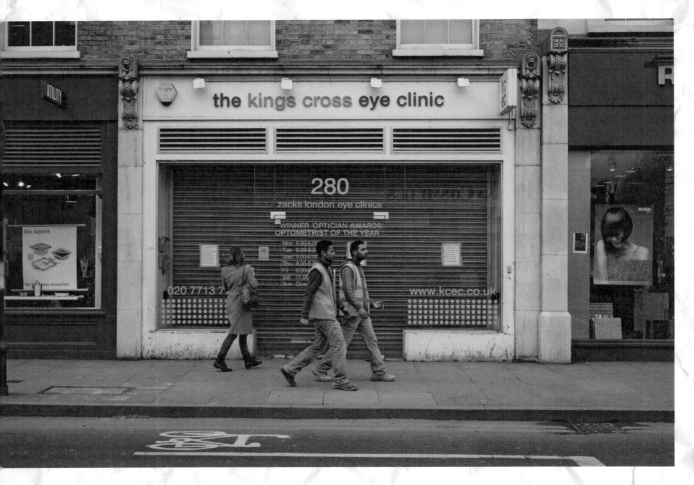

Poorly considered name, Kings Cross

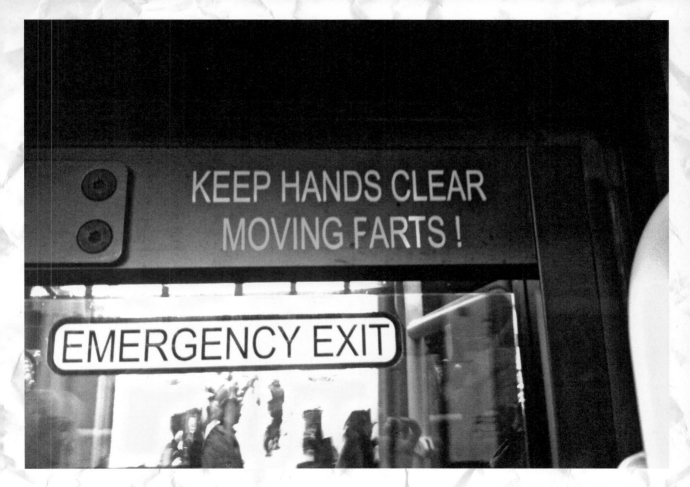

Route 73, Oxford Street

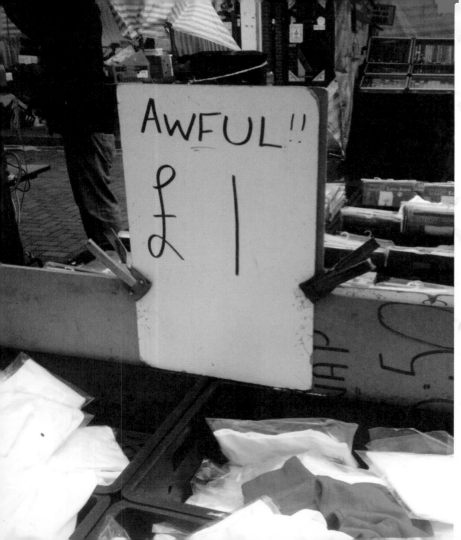

Refreshingly honest, Deptford

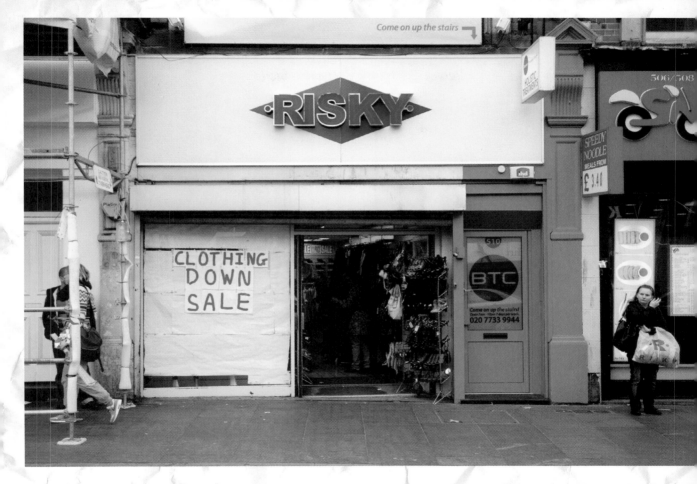

Sign with a lisp, Brixton

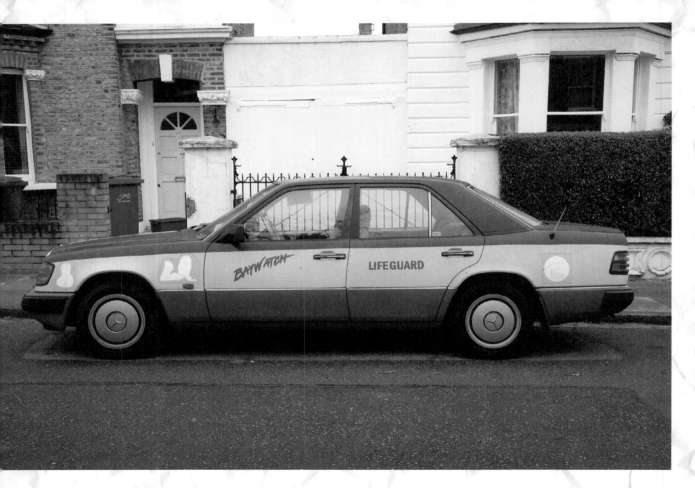

Baywatch inspired paint job, Dulwich

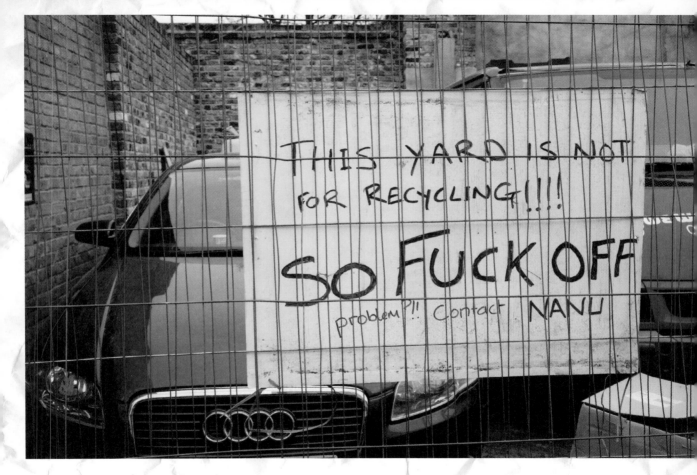

Problem?!!, Bow Road

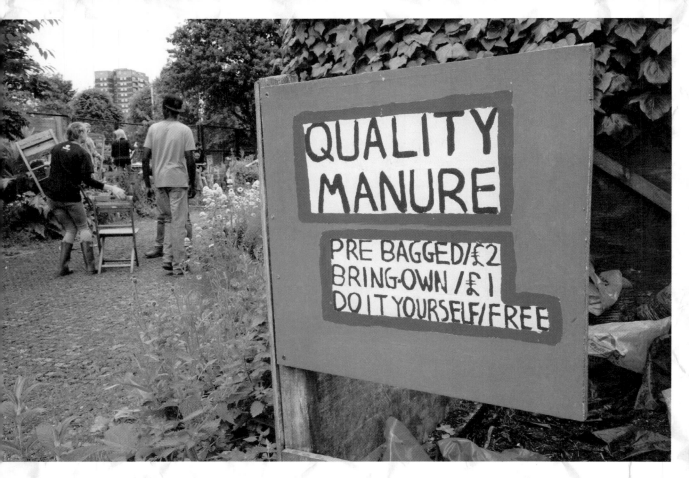

QUALITY MANURE

PRE BAGGED / £2
BRING OWN / £1
DO IT YOURSELF / FREE

Do it yourself, Spitalfields City Farm

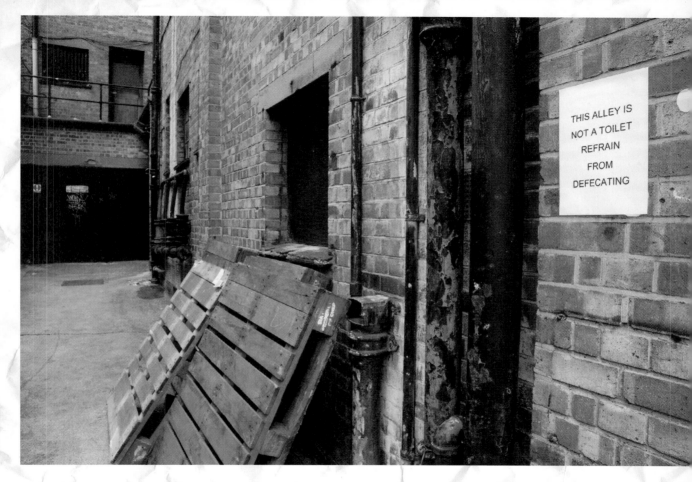

Don't do it at all, Tooting

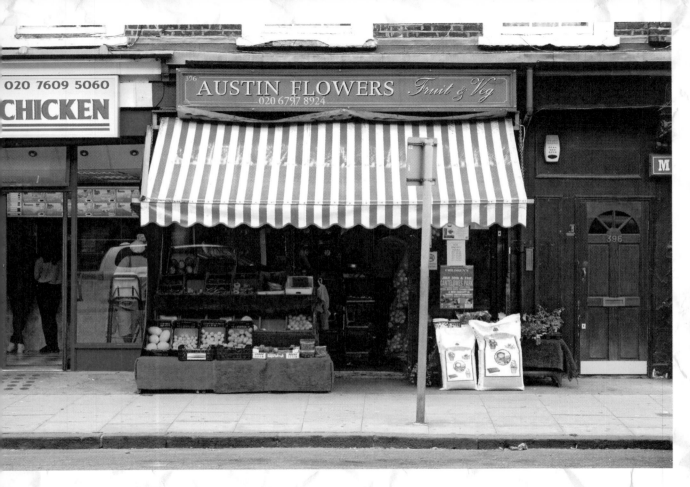

International man of floristry, Camden

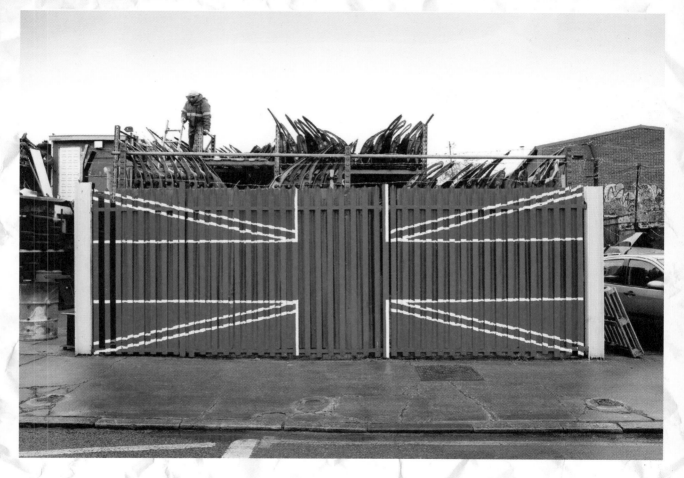

Patriotic gates, Hackney Wick

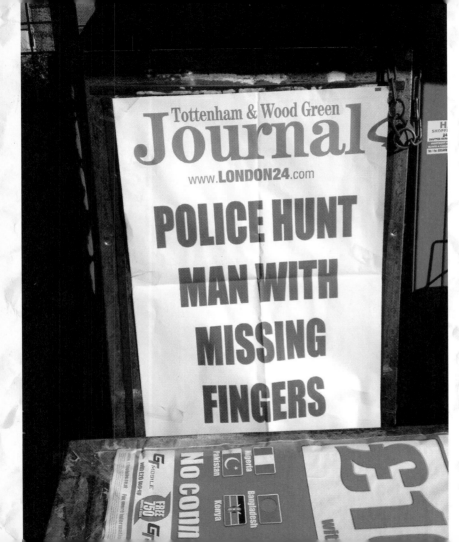

Beyond light fingered, Wood Green

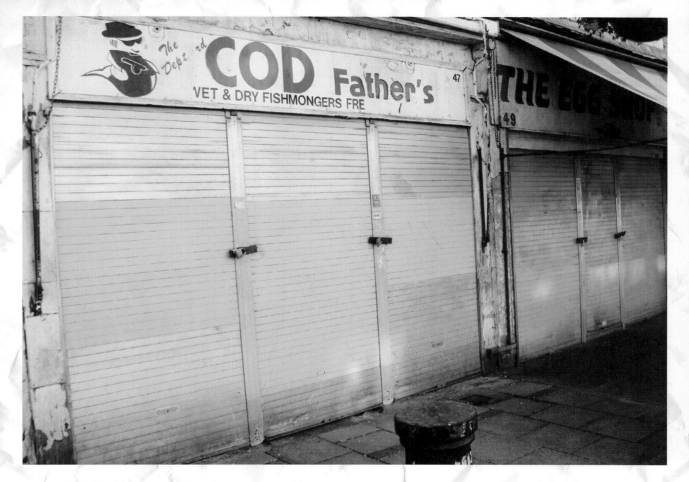

Organised crime/fish pun #1, Deptford

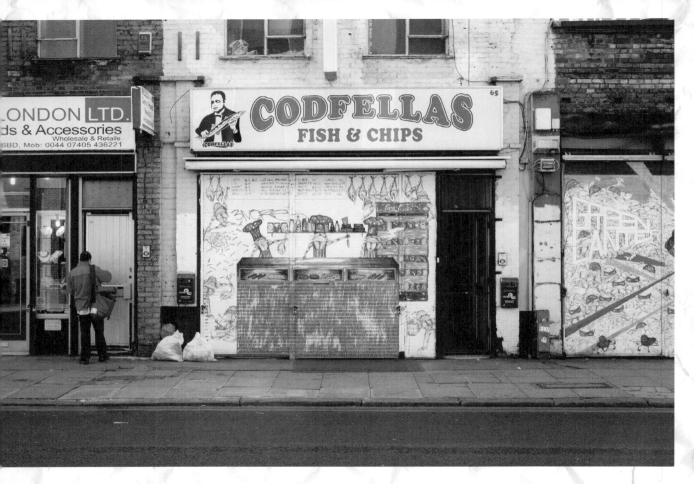

Organised crime/fish pun #2, Spitalfields

TFL

Caution
Touting mini cab

These are completely illegal and are bad news, avoid them like the plague. They wait for unsuspecting tourists who do not know any better, usually in places such as central London and railway stations. They will appear to be friendly and helpful, carrying your bag from the train station outside to the car.
Remember that mini cabs cannot pick you up on the street, so if it looks like a private car, not a big black taxi, then you should refuse to get in. Take your bags and leave. There have been cases whereby tourists have been taken only a few blocks and then charged £60 or more. If you refuse to pay you could really be in trouble as they tend to have some very big friends that could land you in hospital
MAYOR OF LONDON

Unofficial Mayor's notice,
Kentish Town

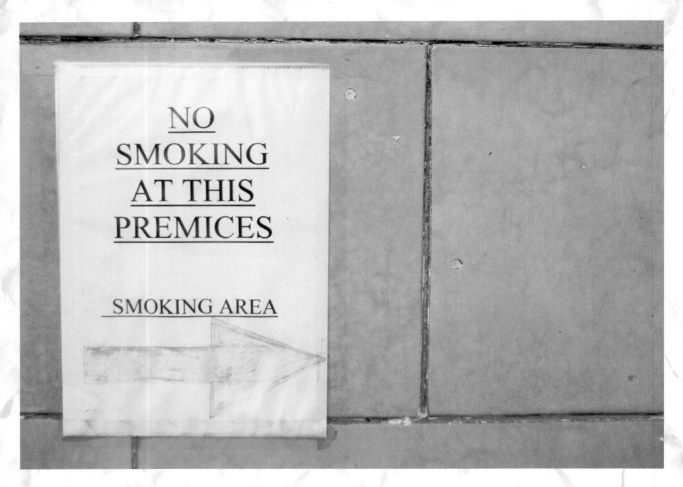

Bad grammar galore, Columbia Road

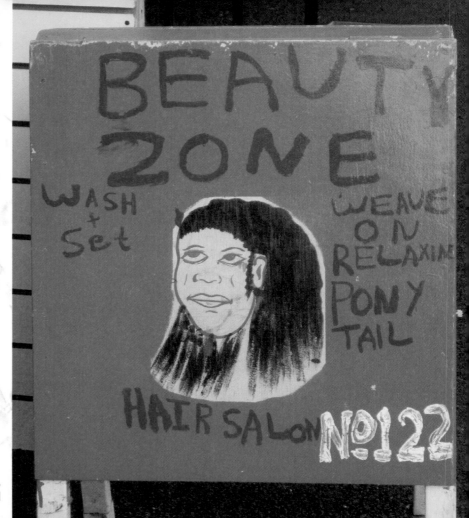

Counterproductive sign,
Ridley Road

Terrible lunch pun, Kentish Town

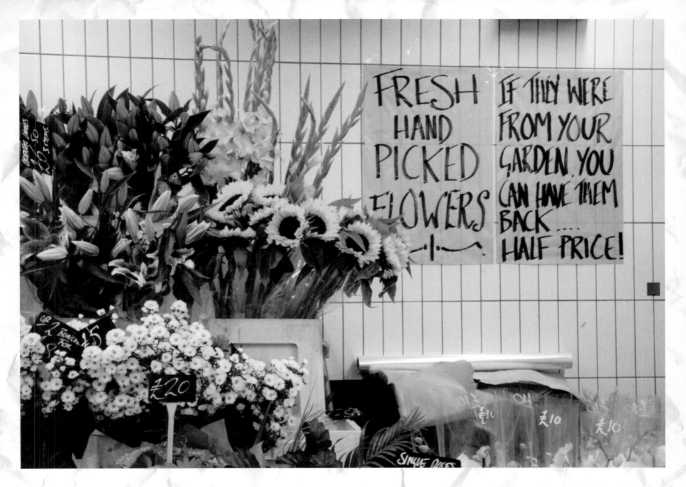

Flawed offer, Kilburn

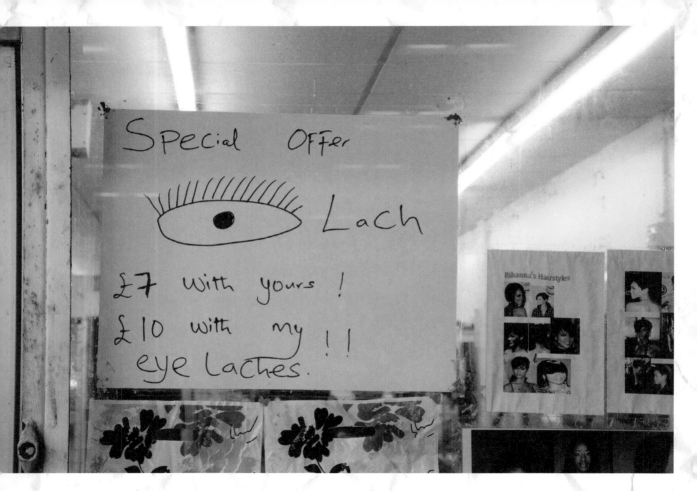

Hairdresser's window, West Ham

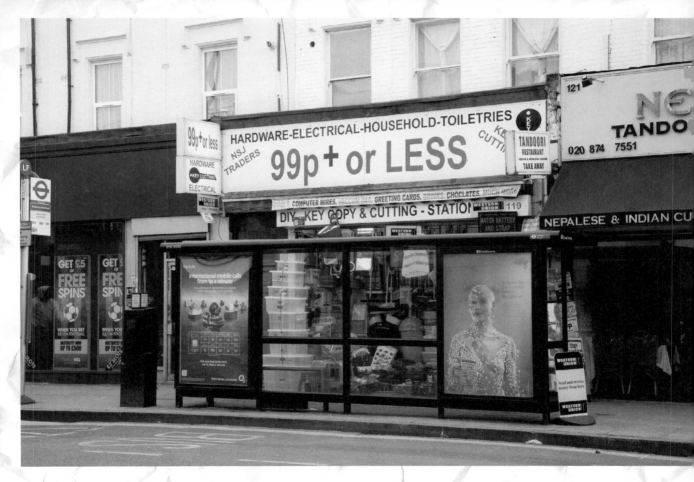

Pound shop fail #1, Shepherds Bush

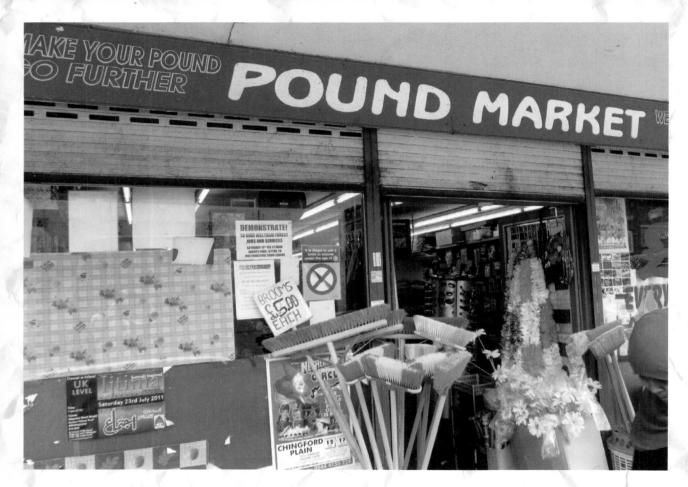

Pound shop fail #2, Walthamstow

This toilet cubicle is out of order - Please use alternative cubical.

Sorry for any inconvenience caused

CENTRE COURT
SHOPPING, WIMBLEDON

Same word spelt differently in same sign, Wimbledon

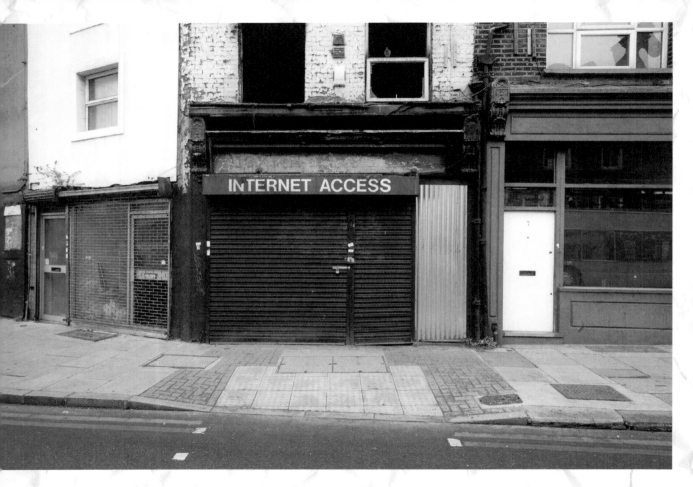

For pigeons only, Deptford

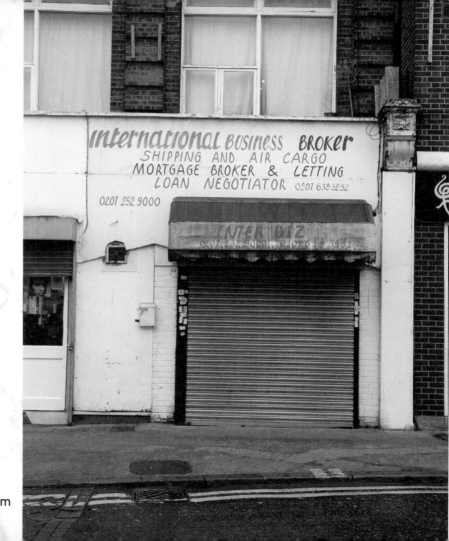

Multifaceted business, Peckham

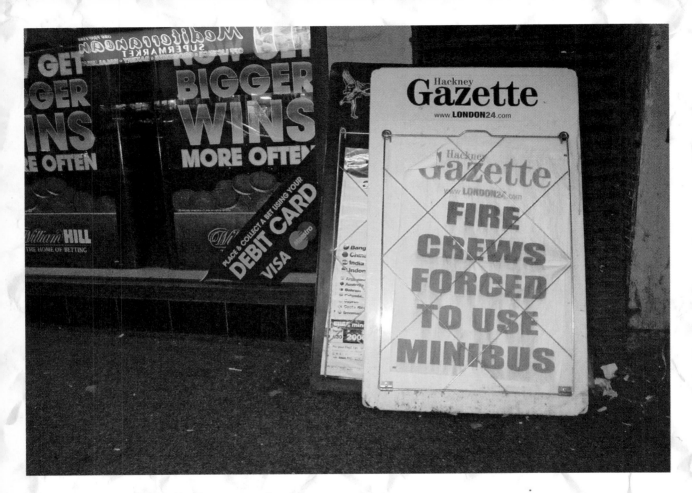

London's burning, Stoke Newington

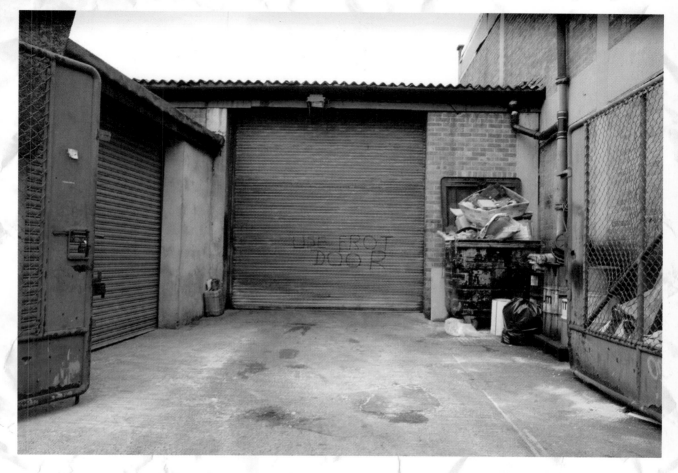

Garage door, Hackney Wick

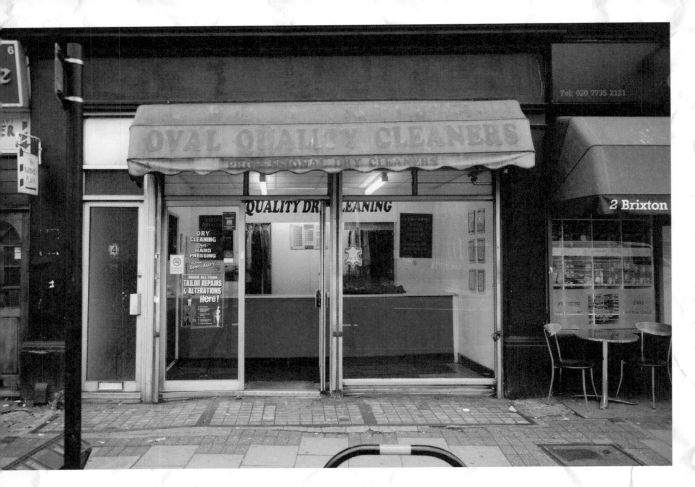

Quality cleaners, dirty awnings, Oval

One follows the other, Palmers Green

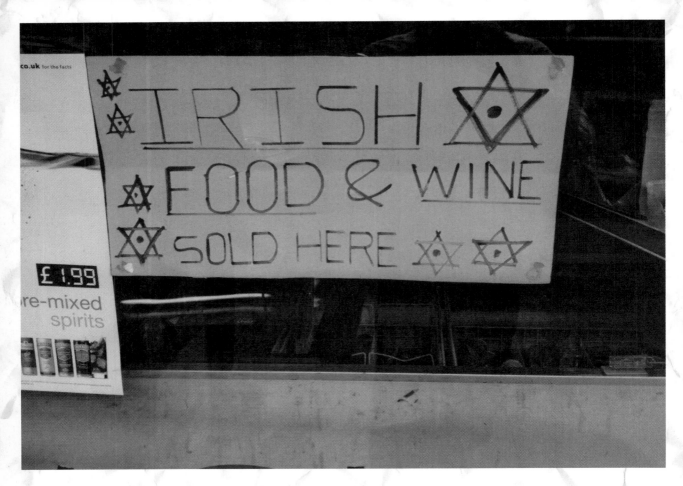

The star of St Patrick, Acton

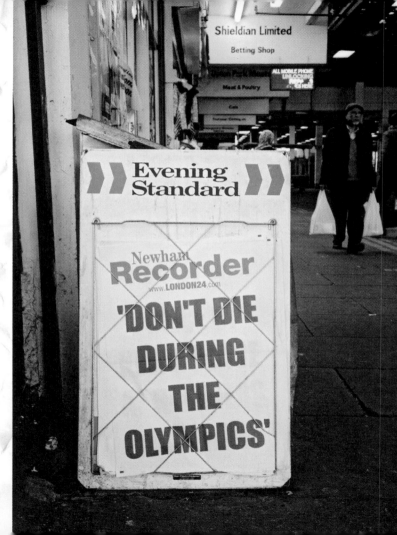

Stayin' alive, Newham

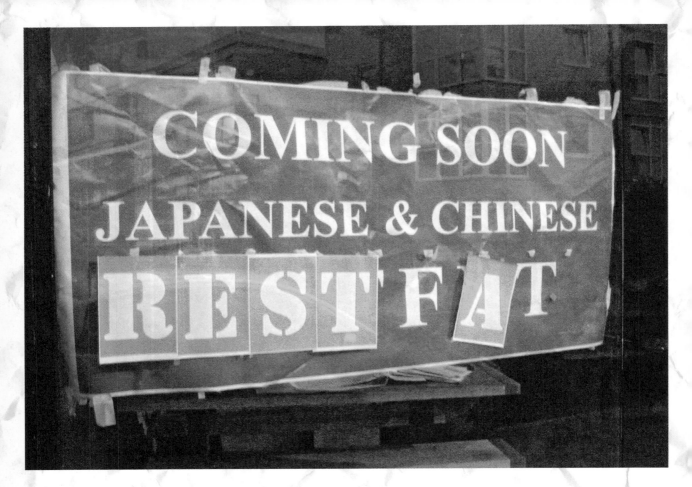

Coming soon, Merton

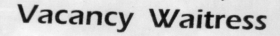

Vacancy Waitress

- Panctual
- Friendly
- Good english
- Smart

Give your CV or leave your detail inside

Job advert, Soho

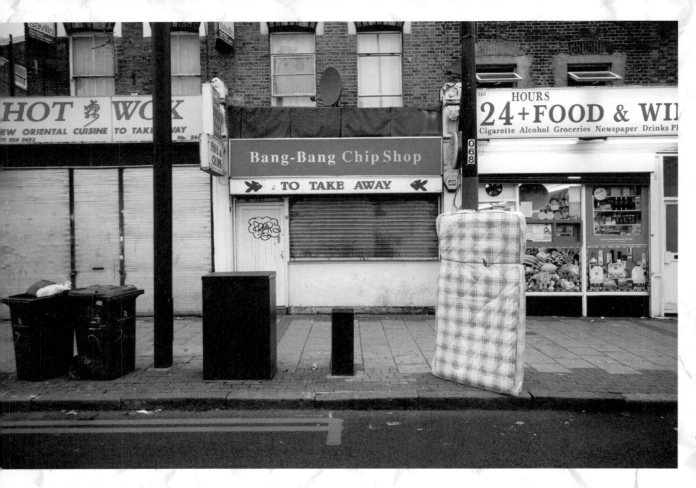

Drive-by chip shop, Brixton

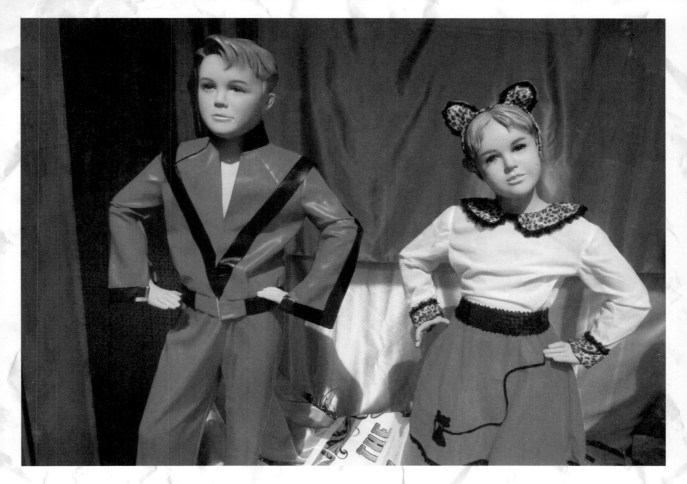

Scary mannequins, Dalston

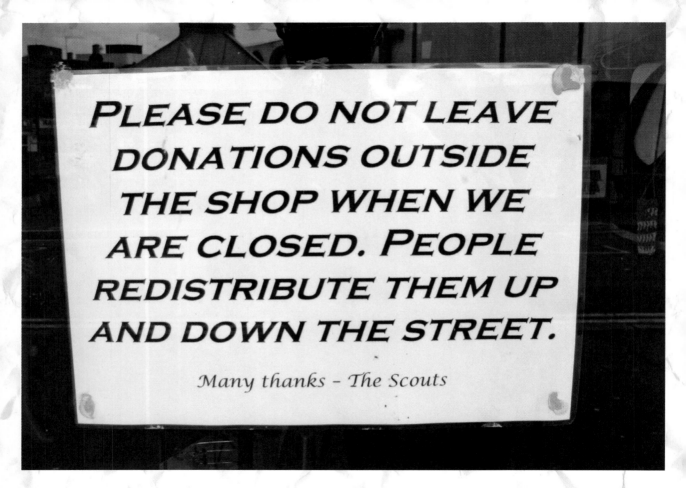

PLEASE DO NOT LEAVE DONATIONS OUTSIDE THE SHOP WHEN WE ARE CLOSED. PEOPLE REDISTRIBUTE THEM UP AND DOWN THE STREET.

Many thanks – The Scouts

Dib dib dib, rob rob rob, Hackney

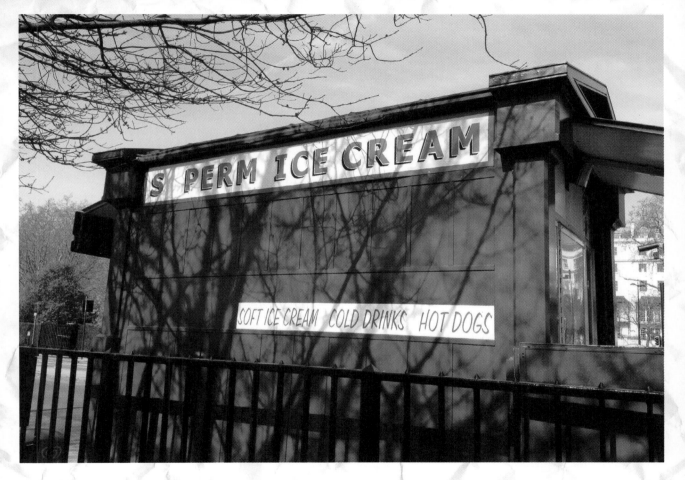

Two scoops please, Hyde Park

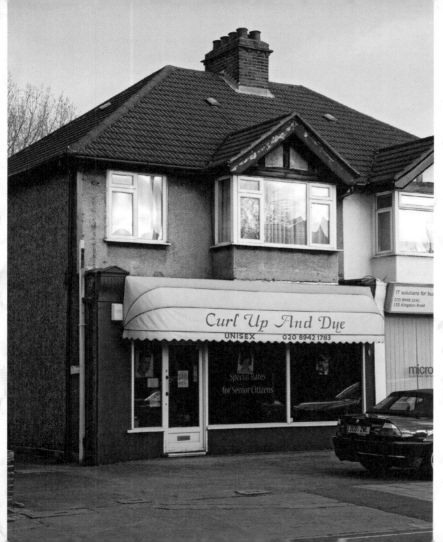

Hairdresser's death pun,
New Malden

Knobism debate, Green Park Tube

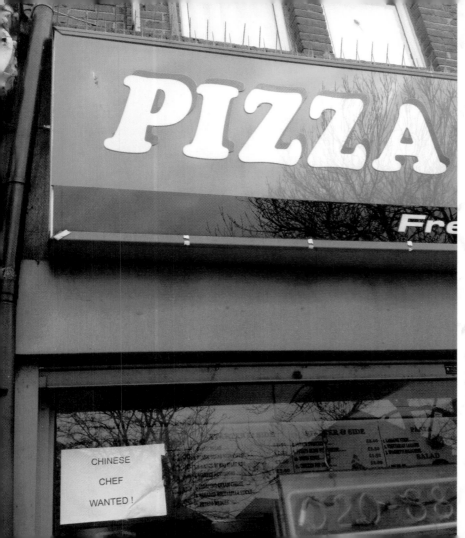

Culture clash, Wood Green

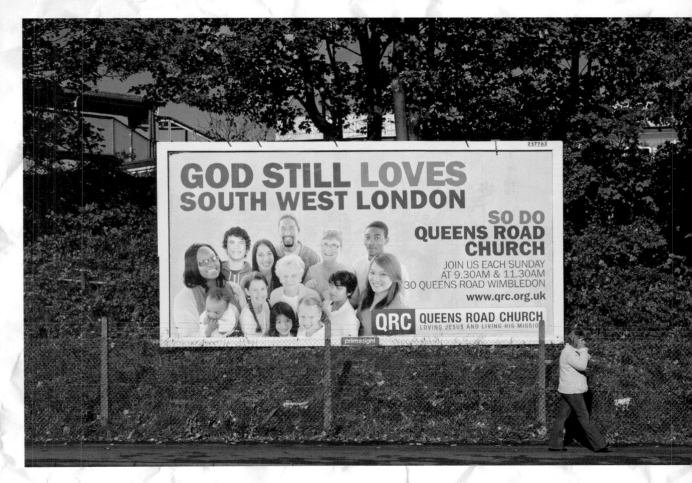

... but the rest of it can go to Hell!, Raynes Park

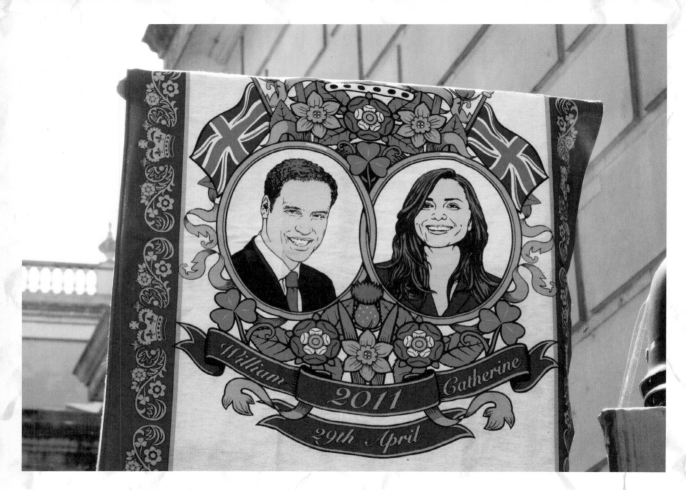

Grotesque tea towel, Westminster

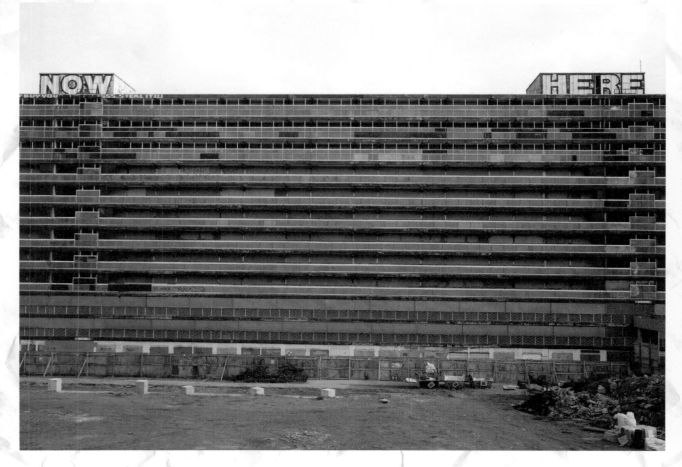

Bleak house, Heygate Estate

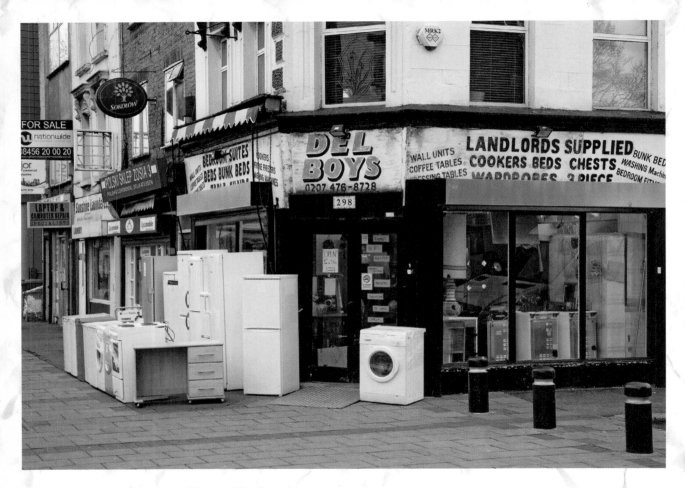

Only Fools and Horses themed shop #2, Plaistow

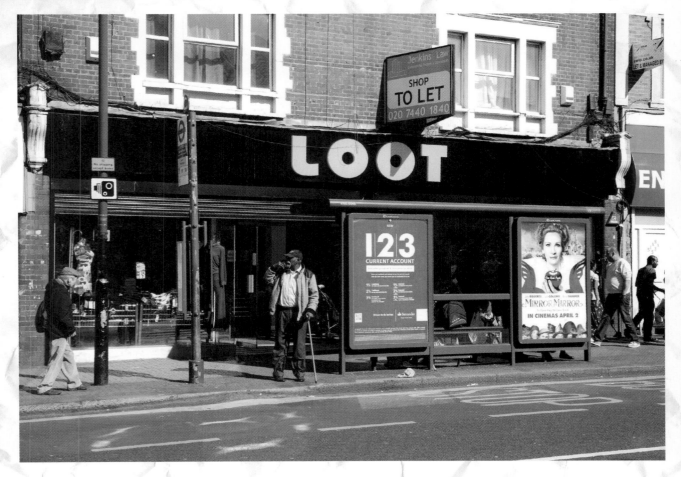

Open invitation, Tooting Broadway

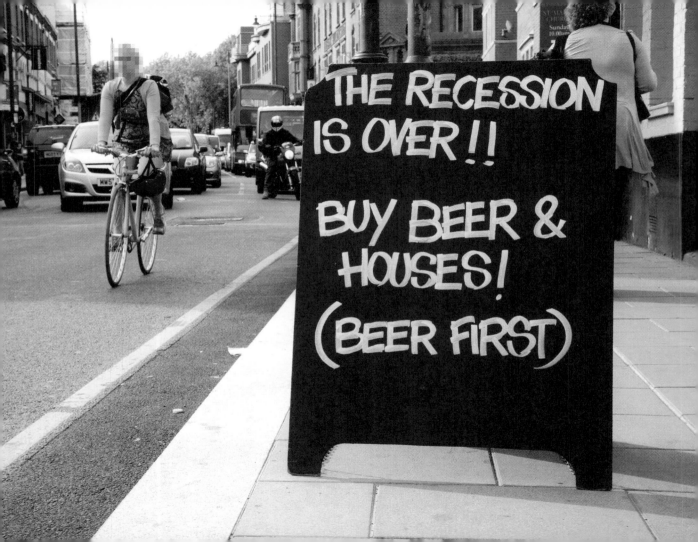

CONTRIBUTING PHOTOGRAPHERS

Chris Barrett, Jon Burns, Max Halley, Catherine Gibbons, Ed Pentelow, Angela Morris, Nadi Jahangiri, Lindsey Tulley, Donal O'Dowd, Michael Cosgrave, Jack McGinity, Iain H Hambling, Jonathan Broadbent, Jessica Bestenless, Louise Perry, Sharon John, Sharon Day, James Elphick, Sophie Epstone, Liv Murton, George Meek, Jake and Janet Wakstein, Daniel Alexander, Ruben Avila Haro, Molly Gilbert, James Hunt, Lynne Taylor, Aysha Chaudry, Charlotte Junker, Marlon Dev Alegata.

ACKNOWLEDGEMENTS

In no particular order I'd like to thank ...
My long-suffering friends and family, everyone who contributes to the *Shit London* blog, everyone who emails me with tip-offs, Laura Middlehurst, Claire Martin and Nick Hartwright at the Mill Co Project, Dan Alexander and Amanda Sue Rope for all the soup, that angry kebab shop owner for not killing me with his kebab sword and Malcolm Croft and Angharad O'Neill at Portico. Most of all, I'd like to thank the people of London for never failing to surprise me.

Also by Patrick Dalton
Shit London, ISBN 9781907554346
Rude London, ISBN 9781907554452

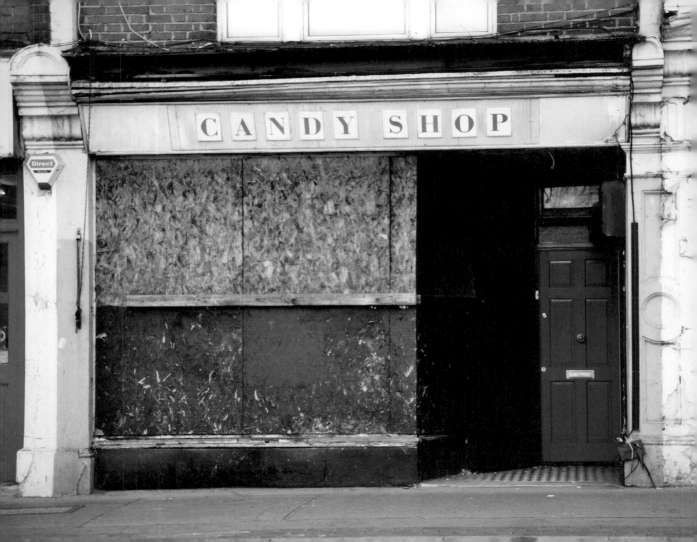